TOO LATE TO TURN
BACK NOW

Too Late to Turn Back Now

Prose & Poems, 1980–2016

Finn Wilcox

All inquiries should be addressed to:
Empty Bowl Press
a division of Pleasure Boat Studio: A Literary Press
201 West 89th Street, 6F
New York, NY 10024
www.pleasureboatstudio.com
pleasboat@nyc.rr.com

Library of Congress Control Number: 2017941644
Poetry
ISBN 978-0-912887-52-4

Cover: University of Washington Libraries, Special Collections, Mary Randlett, photographer, UW38036; "Bird sculpture" by Philip McCracken for the Kingdome, July, 1978.

Author photo (The Poet & Delilah) by Katherine Geers
All photographs included in text © by Steven R. Johnson

Book design by Tonya Namura. Printed at Thomson Shore.

For my wife, partner and love of my life of forty years,
Pat Fitzgerald.

For my son, Dane, and daughter-in-law, Rebekah.

For my son, Shi, and grandson, Zachariah.

Acknowledgments

Here Among the Sacrificed was published in 1984 by Empty Bowl Press, Port Townsend, Washington.

Nine Flower Mountain (2002) and *Lesson Learned* (2008) were both published as chapbooks by Jerry Reddan's Tangram Press, Berkeley, California.

The poems, "Art," "Two for Tom Jay," "End of Contract," "Spring," "Catching Out," "Tacoma Bust," "After the Blow," "Bad Track," "Sliver Lining," and "Headed Home," were published under the title, *Freight Train*, in 2011 by Bob & Susan Arnold's Longhouse Press, Green River, Vermont.

"Not Letting Go" was published in 2016 by Good Deed Rain Press in an anthology called, *A Flutter of Birds Passing Through Heaven: A tribute to Robert Sund*, Edited by Allen Frost and Paul Piper.

A special thanks to Michael Daley, Tim McNulty, Mike O'Connor and Uncle Bill Porter for their keen eye to detail and stellar editorial skills that made this book better.

My gratitude to family, extended family, and friends, would quite literally take reams of paper to properly express, so I won't even try. Just know how lucky I feel to be floating around space on this goofy old planet with the likes of you folks. You know who you are.

TABLE OF CONTENTS

Too Late to Turn Back Now

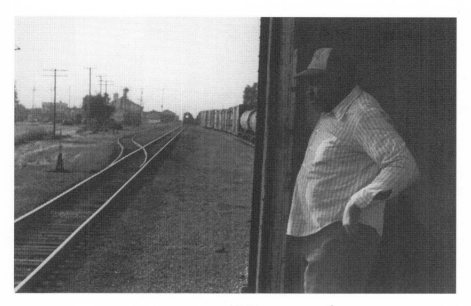

HERE AMONG
THE SACRIFICED

"The hobo has two watches you can't buy in Tiffany's, on one wrist the sun, on the other wrist the moon, both hands are made of sky."

—Jack Kerouac

there's a homelessness leads one
to sleep where he may
a loneliness
brings one to a cricket's call
at dusk

—Tim McNulty

Zoo

There is a stretch of the Odgen River that snakes its way through the major railroad yards outside Ogden, Utah. On one side of its banks runs the mainline into the Rio Grande and Southern Pacific yards; on the other, old cottonwood trees covered with years of blowing red railroad dust. These groves are where the hobos and tramps jungle a night or two before picking up and moving on.

Zoo saw the scattered campfires through the trees even before he jumped off the train. He moved his bedroll down the railroad embankment and watched the rest of his train rattle past. It had been a good ride. Two days on the same boxcar, a fine old boxcar with wood floors and plenty of clean cardboard to sleep on. Zoo looked down the tracks as the caboose went by and watched the six tired units that pulled him over the Rockies bend slowly around the muddy river and disappear into the Rio Grande yards.

It was getting dark and Zoo wanted to cross the river while he still had light. He rebundled his gear and tied it with rope to make a sling he could slip over his shoulder. Downstream he could see where the river widened out and was shallow enough to cross. He walked to where the weeds grew high along the edge of the river and found a small, well beaten footpath that turned slowly into a tunnel of cattails and water reeds that hung close to the slow moving Ogden. Zoo thought he loved this jungle best with its shining river banks and ancient trees that dropped their fruit like dandelions...

It was beach only part of the year. During the spring it was a sandbar sunk deep beneath the swollen river. Zoo kicked at the ashes of a dead fire near the shallows and saw that the river left a strata of muddy camps from years past. He could hear wind off the water and the muffled voices of men as he crossed the evening river.

"Comin' inta camp, anyone mind if I come inta camp?"

Zoo had learned long ago not to approach a fire before announcing himself. To do so was not polite or safe. He waited beyond the firelight in the darkness:

"I got a little food I can kick in if you're cookin' up," he yelled out.

"Well I'll be damned, is that you, Zoo?"

"Yo! who's that?"

"It's me, Frisco Blacky—been wonderin' what's happened ta you. Come on over ta the fire an get somethin' ta eat."

Zoo picked up his bedroll and walked into the bright jungle. He knew at a glance it was Blacky's camp by the order of things—cans washed and stacked, old newspapers folded neatly and two days of firewood already gathered for the next man who came through. He greeted his old friend warmly. It had been a long time since he'd jungled with Frisco Blacky. Zoo took one of the washed cans and filled it with stew, then sat down next to the fire. As he ate he listened to Blacky's news of the road. With Blacky, he always felt what he heard was true.

Zoo finished his meal and set his can aside. From his pack he pulled out a pint of white port, opened it and handed it over to Blacky. When the bottle was empty he spread out his blanket under a cottonwood and lay in the dark watching the moon and stars float above the river. "Tomorrow," Zoo thought to himself, "I'll have breakfast with Blacky, then head west to Oregon." He shut his eyes and listened awhile to the crickets singing with a single frog before falling asleep.

Seattle to L.A. (Train Journal)

Jim and I meet Steve right on time at the Wheeler tavern. Perfect bar to meet at: only a block from the yards, nice people, and cheap beer. Barbara and Jeremiah are supposed to meet us here on their way back to Bellingham from Portland so I decide to check the yards while Steve and Jim wait for Barbara. The first train I see pointed south is already hooked up and seems ready to go. I find a brakeman and he tells me it will be going to L.A. in an hour or two. I climb up the railroad embankment and back to the bar with the good news. Barbara and Jeremiah have shown up so I have a couple of beers with Barbara and give her the latest update on Pat and the kids and what's going on in Port Townsend. Finally it's time to go so we all get our turns hugging Barbara, then Jeremiah, and it's all so sad somehow. After many "good-bye's" and "be careful's" the old Volvo pulls onto the highway and they are gone.

We walk across the road into the weeds where the small wino trail leads to the trains. Search for empty boxcars but only find empty car carriers so we pile on one and make ourselves comfortable for the coming thirty-six hour ride. After an hour or so our train begins to move and we slowly leave the Interbay yards.

I have never gotten to Vancouver from Seattle in any reasonable amount of time; this trip is no exception. We move slowly and make frequent mysterious stops. The difference this time being that just outside the Amtrak station our train stops and a railroad bull boards her with evil sweeps of his flashlight. The car carrier we ride offers no real protection against a shining light so we try to figure what to do as we watch the flashlight grow brighter and brighter—the bull heading our direction.

"Let's move our gear to the back where it's dark. Maybe he won't see us if we're still and keep down."

"He'll see us alright. I think we should get off and hide. Wait for him to finish checking the train, then get back on, or catch her on the fly . . ."

"Yeah, but he'll be here soon and I'm not sure we have the time to..." Holy shit! there he is, out of nowhere, standing in the doorway of the carrier directly behind us. We freeze. How'd he get here so fast? What to do now?

Moving slow and quiet, we ease our way to the back of our car and try to keep out of sight the best we can. Heart thumping, I watch the bull standing over two hobos who'd been sleeping when he found them: "O.K. boys, recess is over. Get your gear and get off." The two tramps get their stuff together and jump off the train, flashlights shining on them from outside the door. We think it is certain bust for us too and are almost resigned to the fact when suddenly, Bang! our train lurches forward and we start moving.

The moment we realize we are saved, big grins and 'FUCK WAS THAT EVER CLOSE' looks in our eyes. We open one of Jim's tall beers and gather together to talk about what has just happened. Steve says it is a sign, the ghost of things to come, and we should be more careful about keeping out of sight when we pass through strange yards. We all agree and open a second tall beer to celebrate our escape. The night grows cold. We wrap up in sleeping bags and everyone falls asleep from the excitement of the first day out and a close call so soon and it's two in the new morning.

THE BONEYARDS

We camp by an abandoned warehouse
just outside the city limits
of Mason City, Iowa.

The fire is nearly out
and my partner's
asleep.

I throw the last wood pallet
on the burning coals
and lean against a pile of bricks.

The derelict factory looms
above our camp
in the crackling light.

Another clear night
in the boneyards
of America—

the smell of rusting steel
and forgotten men
mingle in the wild starlight.

I roll out blankets
between sleeping tramps,
finish off what wine is left

and listen to far off dogs
sing their songs
to one another.

The dark landscape
lifts and falls
with a sigh
and all the iron and concrete
heaped into order
can't keep these single blades
of grass from breaking through

back into the world.

DERAIL

Our train moves slow
as an old chinaman's bow
past an ancient derail...

The engineer blows his whistle
straight through the roaring darkness
in homage to
the spirits that live there.

I shift positions on the
boxcar floor, wrap up
tight in a dirty sleeping bag
and think of poor Odysseus
and his singing Sirens...

It's late.
The night has eaten
what moon there was;
· but later
on those dead and twisted
freight cars
the misty galaxies will shine
like frost in the freezing night.

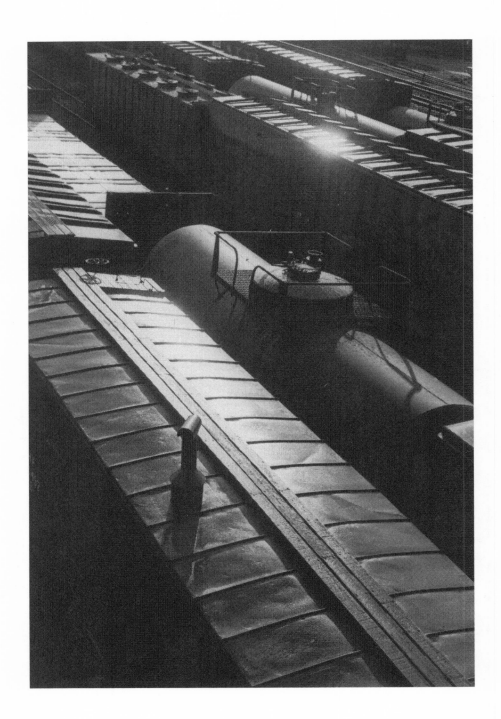

I remember waking once and it was still dark and cold outside my sleeping bag and so tired and warm inside I just couldn't get it together to go talk with a worker and find out what was happening. I knew they were either taking or adding cars to our train: Crash! we stop, then start moving backwards —Crash! we stop, start moving forward again. This goes on for what seems like eternity.

Wake up with the sun blasting through our car and onto my sleeping bag. Too hot. I climb out of my bag and jump off to piss. The train is short now, no caboose in back, no units up front, and I think to myself, 'sonofabitch, why didn't I get up when I knew I should of...' and walk on down the yards enjoying, finally, the warm railroad morning. It's now clear that we've been dropped off on a side track and our thirty-six hour ride to L.A. has gone on without us. I walk the tracks to the south end of the yard looking for a brakeman or switchman I can get information from. But it's a dead yard. No one around for miles.

When I get back to our car, Steve and Jim are packed up and making breakfast. I tell them the yard is dead and no one's to be found.

"Maybe we should take the city bus on into Portland. It's only fifty cents or seventy-five at most. If we work it right, catch the twelve noon hot shot from the Terminal yard."

Fifteen minute bus ride from Vancouver to Portland—only fifty cents. We sit up close to the driver and talk with him about tree planting and riding the trains. The bus crosses the bridge into Portland, turns off the freeway and loops down into the industrial area along the Terminal yards. We see switch engines moving lines of flatcars and tell the driver anywhere he can stop is fine.

"Well, thanks for the ride."

"Sure thing, you boys be careful. Long ways to Los Angeles."

The yard is flat and open except for a young stand of willows growing right in the middle. Gather our gear, hop two flatcars and head for the small grove of trees. We find a clearing among the saplings and unload our stuff. Steve takes off across the yard to find out about the noon hot shot to L.A. This is the perfect place to be—enough trees to keep out of sight, yet clear enough to watch new trains being made up. When Steve returns he tells us they are no longer running the noon hot shot and the next train won't leave until five in the morning. We talk it over and decide to stay the night— catch the five a.m. train out tomorrow. So Steve and Jim nap in the tall grass and I read all afternoon under hot blue skies. Toward evening Steve gets restless and wants to have a beer in town. He and Jim take a city bus into Portland and drink beers in a topless bar and buy three bottles of wine for my birthday. I stay with all the gear in the jungle and after dark throw a warm blanket over myself to watch the stars come out in comfort. Steve and Jim get back to camp late. We drink their last two cans of beer and sit around our small fire laughing, making plans for tomorrow and our five a.m. southbound train.

GOOD NIGHT CRUMMY WILLY

Crummy Willy lifts the can off the fire and stirs the beans with a small stick. He is tired from a long day on a slow train:

" ...damn me if that wasn't the slowest ride I've ever had, and that kid, somethin' wrong with him. Kept offerin' food to 'em, wouldn't eat a thing, said it's no good for ya, too much of this or that in it—'well what the hell,' I told 'em, 'ya gotta eat and eat whatever ya can get...' I think he escaped from some kinda nut house or somethin', he seemed sorta touched ta me..."

Willy shaking his head and scratching at his foot by the firelight—

" ...an he didn't drink or smoke or wanna talk. I think he was a little touched."

Willy pours the beans and hamhocks from the big can into our smaller ones and while we fill our empty bellies he talks about the fine free lives we are living.

"It's like I told that crazy kid," says Willy, "there's two things in my life I've never missed: a meal is one and a freight train is the other. Now I ain't sayin' I haven't put that meal off a day or two, an them trains left more'n once when I wasn't ready ta go, but I ain't missed either of 'em yet."

Willy climbs under his dirty blankets grinning, tickled with his joke—knowing we were too.

"Well it's time for this old fart ta get some sleep. Gonna be a big day tomorrow. Good night fellas."

"Good night Crummy Willy."

"Finn, wake up." I open my eyes. Steve is standing over me, gently shaking my shoulder. "I've been over talking with the brakeman. Our train leaves in half an hour."

I get out of my bag and stretch. Everything is covered with dew and the morning sky bright with stars. As I pack my stuff I hear a switch engine banging freight cars together like some huge typewriter finishing off a long American story and I tell this to Jim as we head across the dark yard to find Steve and his empty car.

We spot him down the train working at getting one of the boxcar doors open. He has a railroad spike jammed between the door trying to pry it. We throw our gear into the other side and climb over the coupling to help him slide it open. This done, search the boxcar for cardboard to sit on and find plenty for the three of us. Jim sits down next to me and pulls out a bottle of cheap wine, twists the cap off with one spin and hands me the bottle. "Happy birthday to you..." Sit for an hour, legs hanging out the door, passing the first bottle of birthday wine around in the cool dawn. As the last delicate pinks and lavender disappear from the eastern sky, we hear the highball whistle blow and our train lurches forward with a squawk.

A beautiful warm morning and we couldn't ask for a smoother riding car. Sometimes you'll catch a boxcar that's been on the line so many years its wheels wear flat—there is no meaner ride than an old flatwheeler. You can't sit or lie down, yet you can't really stand either unless you bend your knees slightly to absorb the shock from all the bouncing. Your only hope once you're on one is that the train will stop soon so you can get the hell off. But not today. Today we sit in the sun next to the open door and watch the Oregon countryside roll by.

By early afternoon our train switches off the mainline into the Eugene yards. We're not sure what happens from

here. After it stops, we hear the units disconnect. (What happens is the engines cut the air to the brakes and it makes a tremendous Spsshhhh! sound that signals some major change to the train. Maybe they will add five or six more cars, maybe take half the cars off and leave them in the yard or maybe none of those things, so you must move fast and find out from the workers what your train will do...) I jump off and head down the tracks to find a brakeman to ask about southbound trains. Travel half the train looking for someone with no luck, jump across a grain car and see a brakeman poking around the wheels of a flatcar.

"Afternoon. "

He looks up from what he's doing and grins. "Afternoon to you—you just come in on this train?"

"You bet. You know if she's gonna keep on south?"

"Afraid not. This is where we break 'er up. Where abouts ya headed?"

"L.A."

"Well I don't envy you. Got a son lives down there, not enough money in this whole country to keep me in a place like that."

"Yeah, I know what you mean. I'm going to see my brother and his new baby."

He stands up and pulls off his heavy leather railroad gloves, searches all his pockets before producing a crumpled pack of camels.

"Have a butt?"

22

"No thanks."

He lights his cigarette and throws the match to the ground.

"Well, I'll tell ya, where you wanna be is in the north part of the yard—that's where they make up trains going south. Shouldn't have any trouble finding something going to L.A. from there. Everything leaving this yard is goin' east."

"Think anything will be leaving this afternoon?"

"Could be. At least two more trains leave for Roseville and Klamath Falls sometime today. Maybe somethin' going to L. A. too, but Roseville an' K. Falls for sure—see that bridge?" He points to an overpass about half a mile down the yard. "Ya go another quarter mile past there and that'll put ya smack dab in the middle of the north yard—like I say, something be goin' south."

"Great. How about the bulls?"

"Oh, they ain't too bad, keep out of sight though. If they see ya they'll run ya out of the yard." He looks at his watch. "Let's see, it's two now so keep an eye out for a red Ford pick-up. That's what the day shift cop drives but he's off duty in two hours. After about four o'clock watch for a blue station wagon, that'll be Marvin, he don't care too much for hobos so stay out of his way."

"Well okay, thanks for the information. I'll keep my eyes peeled."

"Sure thing. Good luck."

By the time I get back to our car Jim and Steve have figured out that the train is staying and are waiting for me to return. I tell them what I've found out and gather my stuff up so we

can get moving. Rather than walk the tracks and risk getting thrown out of the yard we decide to cut across and walk the freeway to the overpass. We cross five or six trains before getting to the edge of the road and all of us are tired and thirsty by the time we get there. After a short rest we walk the freeway toward the bridge.

As we approach the yard, we can see that there are already four or five trains made up but none of them have units yet. Steve leaves his pack with us and disappears into the north yard to find out what's going on. Jim and I drag all the gear to a small lake across the road from the trains and lie down in the shade while we wait for Steve. When he gets back he tells us the only way to know for sure when a train is going to leave is when we see units come down the tracks and hook onto one of the strings of cars. Could be an hour or it could be ten, so we settle under a shade tree next to the lake and break out the last two bottles of wine. Other than sharing food and water, patience is by far the most important virtue of the hobo: "...if ya wanna ride the freights, ya gotta learn to wait."

By late afternoon we hear the rumble of units coming down the tracks. Jim jumps up and runs to the side of the road to see if they are going to connect to one of the lines of freight cars.

"That's our train alright, they just hooked up and it looks like they're getting ready to put the caboose on, we better get a move on."

Steve caps up what's left of the wine and we take off to look for an empty car. We move fast because once they've put the caboose on, the train is ready to roll. Find an empty boxcar and pile on, excited to be on the go again. After moving our packs to the back of the car we roll out cardboard to lay sleeping bags and blankets on, then I light a candle and we continue my birthday party—Jim and Steve making toast after drunken

toast to the health of the hobos and a long life to me and pretty soon we are all feeling fine in our dimly lit box. A few minutes before the train pulls out Jim hears footsteps in the gravel and motions to Steve and I to quiet down. First thing I think is that we've made so much noise a bull has heard and is coming to check the car. Steve blows out the candle and we push our backs up flat against the darkest part of the boxcar—hoping he will pass without noticing us. The footsteps stop in front of our door and a scruffy blond head pops inside, looking us over with a smile, "I've checked the whole train and this is the only car left with any room." He tosses his pack inside, "Mind if I ride along with you?"

Steve rushes over to the door waving a bottle and offers our new traveling partner a drink. Jim and I help him get the rest of his gear aboard.

His name is Ole. He's from Finland but has been living in the U.S. illegally for the past eight years, doing odd jobs when he can but mostly just hoboing back and forth across America. We make him welcome as any three drunks could—offer him wine which he politely refuses and food which he accepts gratefully and introduce ourselves, when suddenly our boxcar leaps forward and we are on our way again.

Once outside Eugene the train picks up speed and we make good time until reaching the base of the Cascade mountains.

Pull into a small switching yard where our train breaks in half and two more helper units are added to get us over the pass. Gets cold fast as we climb the mountains, finish off the wine and pace the floor flapping our arms and giggling at the cold. Halfway to the summit the snow gets deep and the stars shine so bright it seems there is a full moon when there is no moon at all. Dark pine and fir forests silhouetted against luminous starlit snow. That was the night of my twenty-ninth birthday.

"Other night I'z in Spokaloo waitin' t'catch out on that California man, got so damn cold though I said hell with it an' hot-footed it ta the mission for a shower an' some eats. Musta been a hunerd other tramps there by the time I showed up. We'z all packed in that hall like sardines waitin' for the preachin' ta end so we could get some grub. Well, let me tell you, that preacher got himself real worked up an' kept slammin' his fist down yellin', 'We're gonna take these sinners, these loose women an' prostitutes, an' we're gonna move 'em ta the other side a the river! an' with god's help, we're gonna get all the whisky in town an' we're gonna pour it in the river...!' He was real fired up alright. But he finally cooled down an' time came for 'em t'finish off his message. 'Men, I hope you've gotten somethin' outa my sermon tonight. Is there a favorite song from your hymnal you'd like to close with?' Behind me this skinny little bo stands up an' yells, 'Yeah. Page 86. LET US GATHER BY THE RIVER.'"

Salt Lake Before Noon

Morning blows out
the last star
and already
tall wet grass
along the rails begins to steam...

Across a steel blue
sea of track
the hollow ring of iron
echoes down a string of boxcars
as switch engines
make up the early trains.

We walk north
along the river bank
following the muddy Ogden
through cottonwood stands
and old railroad yards
all rusted
and glittering in the sun...

"If we catch
the Rio Grande,"
you say,
"we'll make
Salt Lake before noon."

We step quickly
between the ties
on well packed ballast;

up the track
poplar trees flicker in the breeze
of a passing freight.

The whole world's in blossom!

and with luck
Salt Lake before noon.

Wake up hung over on a side track next to Klamath Lake. I get up and pull on a couple sweaters, stuff my hands into a pair of gloves and jump out the boxcar door. Everything is covered with a fine April frost, cold even in the morning sun. I look up the train and see we still have units, so take a piss and jump back on our car knowing we haven't been dropped off, most likely just giving the right of way to another train. Sure enough, within a few minutes Jim sees a Southern Pacific freight highballing down the mainline—"Must be a hot shot, she's not slowin' up a bit..." and before we know it she crashes by in a thundering clatter of boxcars, gons, flats, and hopper cars—a roaring blur of steel dust and hot cinders flying off the wheels like shooting stars—clackity clack clackity clack clackity clack....As quickly as it started it ends. We watch the caboose shoot by and wave to a brakeman smoking on its small deck in a silence so deep you think you may never hear again.

We pull back onto the mainline and head on toward Klamath Falls, the town of my youth. Ole and I stand by the door and I point out places along the lake I used to hunt geese with my dog on those frozen Oregon mornings and explain the best I can what it was like growing up in the American West. This is the town I ran away from at sixteen, it is here, in the railroad yard of Klamath Falls, where my father would sometimes roam with his small Bible and mission pamphlets, squatting next to jungle fires hoping to save a few battered souls. Ole talks about Finland and his family and I can tell he misses home terribly. When I ask why he doesn't return he becomes very elusive saying only that he can't. He is a strange man—kind of to himself and brooding—very stoic and determined to coexist peacefully with loneliness. He is also a very likeable and trustworthy partner to ride with.

A few miles past Klamath Falls the landscape begins to go through major changes—hilly and dry and very beautiful. Our train rattles past barley fields covered with ducks and geese herding spring chicks into irrigation canals and small mill ponds—thousands of water birds everywhere—Pintails, Mallards, and Spoonbills burst out of water reeds into a great flapping and feathery cloud.

Within an hour we cross over into California. It has gotten hot so we sit in the cool train breeze by the door and watch the country continue to change. The train snakes around dry volcanic foothills covered with thin grass and scattered pines, small blue creeks and skinny cattle that look tough as coyote. Pull off the mainline outside Weed and let another train pass—to the east stands giant snowbound Shasta mountain, shining white against the noon sky. Thirty or forty miles down the line we start climbing the pass and enter evergreen forest again, then on into Dunsmire. I'd been warned about the Dunsmire yard more than once and already knew that the yard was small and the railroad bulls quick. No sooner had we pulled into the yard than a white truck pulls up to the tracks and some guy spots us sitting in the door of our boxcar, none of us sure if it's a worker or a bull. We're all a little nervous about his seeing us but figure there isn't much we can do about it now. So when the train stops, Steve and Jim take our empty water jugs and walk down to the headwaters of the Sacramento River to fill them. Ole and I stay in the boxcar with the gear. Soon as Jim and Steve disappear into the brush by the river, Ole hears a car door slam and starts moving all his stuff to the back of the box. We pile everything together and are starting to lay cardboard over it when we hear, "You men know it's against the law to ride freight trains?"

We both turn at the same time and see a short slender cop holding his wallet open for us to see his badge.

"Can I see some I.D.?"

We hand it over and as he writes down whatever information it is that railroad agents get off your I.D., he talks about all the trouble these freeloaders cause.

"This winter some colored boys come through here—musta been late January or early February—got so cold here in the mountains they started a fire on the boxcar floor..."

He hands me my driver's license and then takes Ole's.

"...by the time they stopped here the whole damn car was smokin'. Then a bunch of wet backs come through last week and stole everything in town that wasn't nailed down."

He sticks his head in the box door and sees that there are four packs and only two of us.

"You boys ridin' alone, are ya?"

"Yeah, that's right, just me and him."

The yard dick walks to the end of our car, where the coupling connects to a flatcar and scans the river bank with his eyes—all the time talking—

"Them wet backs just got their hands slapped and sent on their way, but far as I know them nigra boys still sittin' in jail. Really pissed S.P. off that one a their boxcars burned up."

Ole and I start moving all the gear to the open door.

"You fellas always carry two packs apiece?"

Ole flashes the bull one of his small tragic smiles and says nothing.

"A hundred foot off the mainline is the end of railroad property. I can't touch ya past there, but consider yourselves warned—my advice to you would be not to get caught in this yard again."

Ole and I jump out of the box door and pack all the gear off railroad property. The bull hops across the train and walks closer to the river, looking for Jim and Steve. From here I can see that it's really a game of cat and mouse. Steve and Jim crouched down by the brush, the cop standing with hands on hips, looking carefully now, knowing they are hiding somewhere. This goes on for quite some time, then the white truck pulls up next to the cop. He talks with the driver for a while then gets in and they drive off.

Wait out the afternoon on a bluff overlooking the yards. Find out the track is being repaired a few miles down the line and that is what's holding things up. Finally units hook up to a train and it starts to move out the yard. We run down the bluff and jump on the ladder of a gondola, hurl our gear on board, and we are gone.

Our train follows the Sacramento River down the pass through short smoky tunnels and over trestles that cross the river. The Sacramento is a river I've never really appreciated before, blue-green in color and moving very fast—a lovely river. None of us are happy about the gon we've caught. It's half full of greasy phone poles and must have carried a load of rock before that, it's so dirty. We have to shovel gravel and scrap iron away to make a place to lay our cardboard

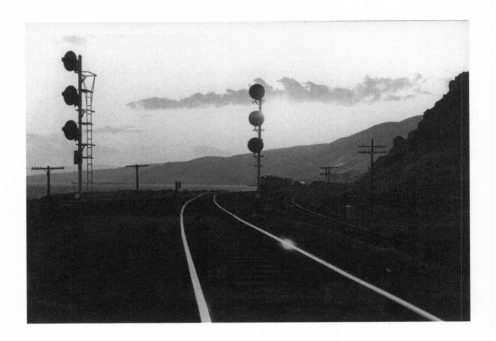

and everyone is uneasy about riding with a load of poles.
There are endless stories of hobos being killed while riding
cars full of pipe or logs—if the load shifts or the train stops
fast you can be crushed in an instant. The view is wonderful
though and the ride fairly smooth, so everyone relaxes a bit
as the day wears on.

Nightfall. A perfect half moon floats above Redding as we
pass through. I kick a few rocks out of the way and roll out
my sleeping bag. Damn dusty gon. Lie my head on my pack,
throw a blanket over myself and drop off to sleep.

A Day in the Life

I.

"Where's the boy?"

"Sleeping inside the shack. He was up most the night looking for us."

The brakeman smiles, walks over to the door and peers in through the window at Chuck asleep on the floor.

"Must be pretty scary losin' your partners on your first ride."

"Yeah, I'll say—worked out fine though, he knew enough to wait for us at the next division. Fred found him in an empty boxcar with an old Indian guy."

The brakeman knew the whole story and had helped us all morning check empties on new trains that came through the yard—hoping Chuck would be on one. He was genuinely pleased that we'd all hooked up again.

"Think I'll go inside an razz 'em a little," says the brakey. He looks over at Fred and I and winks, opens the screen door and lets it slam behind him. A few seconds later:
"...oh yeah," his huge voice booming from the shack, *"cops swarmin' the yard like flies ta shit..."*

"Naw, it can't be me they want," comes Chuck's reply, *"I haven't done anything."*

"It's you alright—red bandana, wearin' overalls, carryin' a brown paper sack and water jug..."

Chuck's up like a shot and out the door mumbling something about always being mistaken for someone he's not and how this isn't the first time it's gotten him in trouble—his boots in one hand, blankets in the other.

"They said ya got some girl in trouble back in Ioway and they got orders to bring ya in."

Chuck steps into the sunlight and stops dead in his tracks, still half asleep but getting it. Fred lets off one of his ear to ear grins, the brakey starts giggling and now Chuck really gets it. He drops his gear and stretches, big smile on his face.

"Fuck you guys," is all he says as he walks back in the shack.

II.

It had been hot and sunny when we left the Minneapolis yards but the weather turned on us a few miles east of Staples. Although the summer rain was a welcome relief from the grueling mid-west heat and helped keep the dust down in the gondola, we knew if we didn't change cars soon it would mean a miserable wet night. Earlier Fred had seen an empty boxcar down the train so we decided to make the switch as soon as we stopped.

By the time we reached Staples the rain had turned to a fine drizzle that was invigorating and pleasant. We packed up when the train stopped, tossed our gear out the gon and climbed down the ladder.

We didn't know for sure how long the train would be in the yard, or even how far down the empty was, so we wasted no time in making for the boxcar. But before we had walked the length of four cars the engines lurched forward sending a crashing shudder down the

train, then slowly it began pulling out the yard. At first we didn't worry too much about it. The train was nearly a mile long and we figured it would take some time to pick up speed; plus we could now let the train bring the empty to us, saving ourselves a walk. But the train got a move on quick and still there was no sign of our box. In a matter of seconds we could see there was no time left to be picky about what to ride and started running with the train. There were a couple of gondolas coming up and we wanted to be running full speed when they reached us so boarding her would go smoothly. Fred was in front of me and I watched him grab the ladder of the first gon that came by and with one graceful hop he was on. Then I caught hold of the next ladder and simply lifted my feet from the ground, the speed of the train pulling me on. I climbed halfway up and hurled my pack into the car, when suddenly I heard Chuck yell, "I dropped the water jug" and this is where the real problem began. I'd found the jug in the St. Paul yards and Chuck knew I wanted to keep it as a gift for a friend back home, so for this reason he stopped to pick it up. Once he got the jug back and his running speed up again it was too late. The train was moving too fast to catch. Fred had watched all this happening from inside the gon and got our gear together—if Chuck couldn't get on we would have to get off. I climbed inside the gon and slung my pack over my shoulder, then Fred headed down one ladder and I climbed down the other. By this time the train was moving fast enough that we had to hang on tight to the rungs of the ladder; we both knew that if we tried to get off now it would mean assholes over elbows through the gravel. Fred looked over at me from the other side of the gon and just shook his head. I leaned out from the ladder and watched Chuck grow smaller and smaller until finally he disappeared from sight altogether. And then the rain started up again.

III.

"Well looky here, the shack's been turned into a hobo Hilton."

I hear the brakeman laughing and open my eyes as he steps over me to get his clipboard off the desk. He's all grins and friendly.

"Skeeters too much for ya last night?"

I sit up and stretch my arms.

"Oh christ, you wouldn't of believed it."

"I dunno 'bout that," he says. "I been workin' this yard thirty years now an' they can get a lot worse than this."

"Yeah? Hope ya don't mind us sleepin' in here last night—it really saved our butts. I've never seen so many mosquitoes in my life."

The brakeman laughs. *"No, I don't mind. Where ya boys headed?"*

"Fred here's headed back to San Francisco and I'm going to Seattle. We lost our partner yesterday in Staples—I checked trains that stopped here last night but he wasn't on any of them."

The brakeman opens his thermos and pours Fred and me coffee and offers us a sandwich.

"Well hell, I'm gonna be switchin' cars around the yard today, I can keep an eye out for 'im. What's he look like?"

IV.

By mid-afternoon we decided it was hopeless and made plans for leaving on the next train west. Chuck had been carrying the food in his pack when we lost him so Fred decided to have one more look through the yard on his way to the store. I waited in the shack with our gear and after an hour or so walked outside to read in the afternoon sun. I was about to sit down when I heard someone yell my name. Down the tracks I could see a figure waving a water jug in the air and by god it looked like Chuck.

He'd spent a long night running around the yard looking for Fred and me and now he was tired and needed some badly missed sleep. When he finished telling me the story of how he'd heard Fred's voice outside his boxcar and how good it was to see him again, he went inside the shack and fell asleep. I stayed outside to read and pretty soon I could see two more people coming up the tracks. It was Fred and the brakeman. Fred had a bottle and the brakeman a big grin on his face. They walked over to where I was sitting and Fred flopped down next to me.

"Where's the boy," asked the brakeman.

"Sleeping inside the shack," I said.

Fred handed me the bottle and I took a long pull off it.

"He was up most the night looking for us."

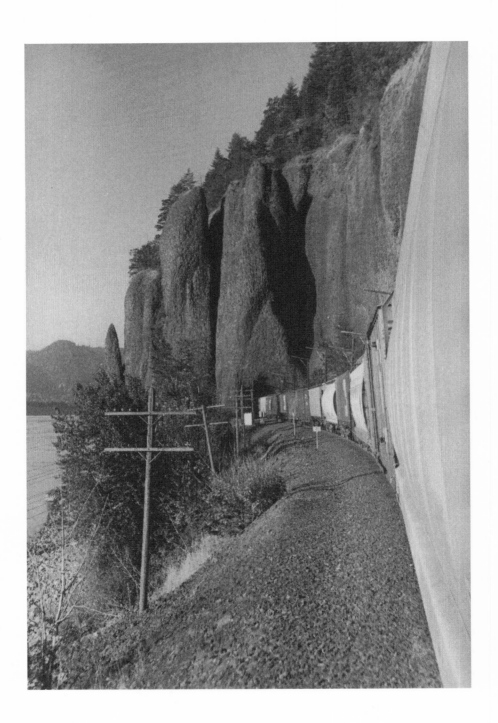

Roll into Roseville around three in the morning, all of us sleeping in the gon. I wake up as the train stops and see Steve climbing out.

"I'll be right back, I'm gonna see if our train'll keep on or break up here."

The rest of us roll up our blankets and get our gear ready. Ole seems nervous. He paces the gon floor awhile then slings his pack onto his shoulder and climbs down the ladder.

"Guess I'll check on trains going to Sacramento, been nice riding with you folks," and he disappears in the early morning darkness. That's the last we saw of Ole.

Steve gets back and tells us half the train is staying and half is going to Los Angeles. We check the half going south but find nothing to ride. All boxcar doors sealed and no hoppers or gons. Find it's two miles down the yard to get to southbound trains. We are beat and all we want to do by now is get somewhere we can sleep. So reluctantly we start walking, dodging between trains the whole way—trying to stay out of sight of the bulls. We reach the end of the yard about the time it starts getting light, find a small creek and throw our gear in the tall river grass growing along its banks. There are a few willow trees for cover and on the other side sits a lone tramp poking at his fire with a stick. No sooner had we settled in for a couple hours sleep when a cop pulls up to the tramp's fire across the creek and gets out of his car. We get down in the brush and stay out of sight. The hobo seems unconcerned in contrast to our quick maneuvers to hide our stuff and ourselves. He looks over at the cop and then back at his fire and waits for the bull to come over to him. They talk awhile and then it becomes clear that the bull is ordering him off railroad property. The old tramp gathers

his bedroll up and the bull climbs back in his car and takes off. He watches after the car as it leaves and when it finally disappears he just drops his gear and sits back down by his fire, adding a few more sticks to it. He didn't give diddly shit about the bull or for that matter jail. Three days in jail to him translated into nine free meals, a shower, and a bed for a couple of nights instead of the ground or a cold boxcar floor.

Sleep in the jungle part of the morning and wake up refreshed. I notice that the old hobo has gone and a man and his young son have replaced him and are fishing on the creek. It is a lovely spring day in the jungles of Roseville.

We eat sardines and cheese, then Jim sneaks across the yard to the herder's shack to find out when something will be made up going south. We take turns doing this throughout the morning until we find the right train. While we read and wait, different travelers off the road drop by the jungle and bullshit a bit before moving on. First an old speed freak headed for San Francisco stopped in and ate a little food. He was a sorry looking bastard with long stringy hair and if he had any teeth left in his mouth I didn't see them. After he left, a group of Mexican farm workers stopped by. None of them spoke a word of English and neither Steve, Jim, or I spoke a word of Spanish. We could tell that they wanted to know what trains were going where, but after a few uncomfortable minutes of trying to make each other understand, either the Mexicans or one of us would throw up our hands, ("no Es Span yol, amigo.") shrug, and give it up with a grin.

By one-thirty we've got everything packed and ready to go. We walk down the yard past the herder's shack and find our train. Steve and Jim go down one side and I walk the other so we don't miss any empties. Just before we reach the end of

the train Jim yells that they've found an open door. I climb across the coupling and throw my gear aboard.

After leaving Roseville I lay in the sunshine by the door and fell asleep. When I woke we were coming into Stockton, Jim and Steve dragging packs to one end of the car.

"Better get up. We'll be in Stockton in a few minutes and it's supposed to be a hot yard."

We pile all our gear together in the corner then sit on top of everything and pull cardboard over ourselves. As we enter the yard our train slows to a crawl and suddenly there are four people running next to our car. I stick my head out from behind the cardboard and see two men throw blankets and food bags into our door, then they jump up and help the other two get on, one of them a woman with a small dog. We throw off the cardboard and move to the door to help them load on their stuff.

"What you fellas doing under all that cardboard?" asks the oldest of the group, a tall slender man who looks to be about sixty or so.

"We heard Stockton's a nasty yard and we should keep out of sight. Someone told Jim that they sometimes check empties so we thought we'd play it safe."

"Naw, these yards ain't bad. They catch ya fartin' around with sealed freight or ridin' a loaded car carrier there'll be trouble, but other than that it ain't hot. Now Fresno or Colton, them yards is hot!"

After we get all their gear on board and everyone gets settled, the old guy shoves his hand out to me.

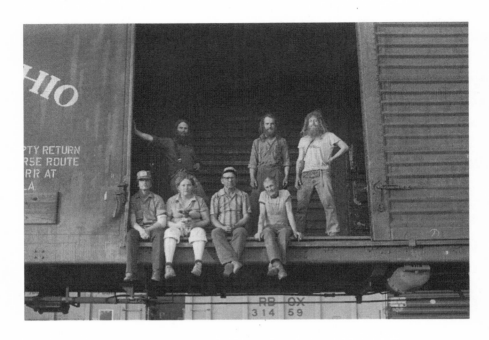

"Name's Ed."

He points to each of his friends as he introduces them.

"This is Jim, Lenny, and Lenny's wife, Vera."

Everyone shakes hands with everyone else, then Vera walks over to us with the pup in her arms and tells us its name is Suzy. Jim and I talk with Ed while Steve drags all the extra cardboard over to our new partners. You can tell Vera is an old hand at traveling by freight train. Immediately she has blankets laid out with food and water neatly placed within reaching distance of anywhere you sit. Fifteen minutes in Stockton then we roll out of the yard, picking up speed quickly as we head south. Ed says our next stop will be Fresno, then Bakersfield.

For the first time since leaving Seattle, the land we travel through now feels absolutely foreign. Apricot orchards, mile after mile of them, and palm trees growing in people's yards. Ed and I stand by the door and complain about the heat while Vera starts dealing out cards to the others sitting on the blankets. Ed is a real talker. A half hour down the line I know all about Lenny, Jim, and Vera.

"Lenny's my nephew. Helped my brother raise him. He and Vera been married about a year now. Vera and Jim are second cousins, known both of them since they was babies. They grew up next door to us and I sorta helped raise them along with Lenny."

Ed gets out his wallet and shows me pictures of his nine kids, then pictures of his nine grandkids.

"After we get to Bakersfield we'll find my daughter and stay at her place, pick fruit a few weeks and visit."

Ed's family connection is large and far reaching, scattered up and down the coast, east to Missouri, south into Texas. A beautiful tight knit anarchy.

Later in the afternoon we pull off the mainline into the Fresno yards. It is hot and all the drinking water we have tastes like warm tub water. Ed and I sit with the others and play poker while waiting for the train to get under way again. Lenny and Vera move to the back of the car where it's coolest and lay out for a nap.

Ed to Jim: "I've been ridin' freight trains since I was fourteen, it's not a bad way to live, of course, there ain't much future in it, if ya know what I mean, but a man could do worse, that's for certain."

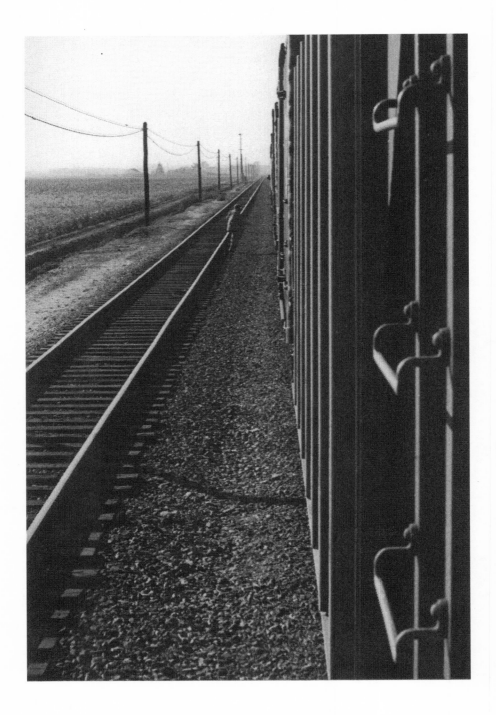

Ed to Steve: "Two more years to go and I can start collectin' my $265 a month social security. You can bet I won't be in this god-forsaken heat then! I'm gonna move up north where it's cool—Oregon or Washington—where there's pine trees and lakes. Get me a small apartment somewhere and just sit in front of the TV with a bottle of wine and a bag of weed. That's right. Just take it easy a few years. No more pickin' these danged hot fields then. That's right. Just take 'er easy a few years."

Ed to me: "Last spring about this time I was in the hospital. I'd been drinkin' wine with some other tramps in a boxcar just out of Lancaster. All I remember is bein' real drunk and walkin' over to the door' cause the stars were so pretty and clear that night. Next thing I knew it was light out and I was layin' face down in the gravel. I had this old dog with me and the cops couldn't get at me to help—every time they'd make a move my way that dog would be up and growlin', he'd a bit one of ' em too if they'd givin' him the chance. I guess I just stepped right out that boxcar door thinking I could fly or somethin'. Broke two ribs and an arm. Doctor said it was lucky I wasn't killed."

Three hours we sit in the Fresno yard telling stories, smoking cigarettes and keeping an eye out for the bulls. When we finally pull out, the sun is a dark rose sinking in a cloud of smog. Everyone is stretched out and asleep.

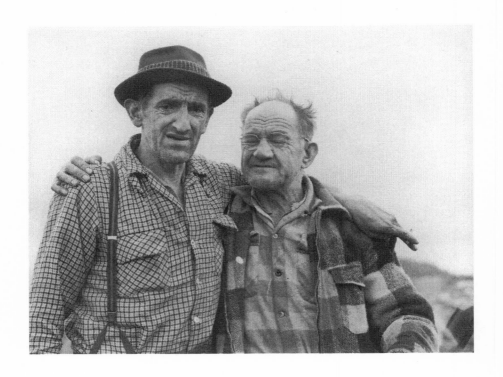

DUMPSTER DINNER

First there are the greens,
always lots of greens
and a few onions
right on top,

they're easy.

Then dig a little deeper
past loaves of turquoise bread
and the smell of souring milk
until you hit cheese...

 and look,
 there's more:

two good tomatoes,
a bunch of carrots,
and a full bag of donuts!

Now load what you can
in a sack and
beat it back to the jungle.

The dumpster dinner
cooks in the pale moonlight—

the dumpster dinner
steams with what you find—

and any tramp will tell you
garbage always tastes better
when cooked outside.

Here Among the Sacrificed

Mojo lies sleeping on cardboard in front of the open door.
His old tramp body
 softly bouncing
 to the rattle chant of freight train wheels.

There is a certain elegance here among the sacrificed—
sunrise slamming cold against desert mountains,
 the first dusty shafts of boxcar light...

and loneliness too finds its mark
on these men who bang across America,
walking through endless tunnels
of gloomy midnight empties,
hunting water for their small sad jugs—
 too tired or drunk
 to climb another coupling—

 "kick me off the train?
 why you sonsabitches oughta
 be payin' me ta ride 'em."

And Mojo sleeps,
sleeps through the gold Nevada morning

his dreams somehow warmed
by the steel clack and shudder

that keeps me on my feet
thinking of home.

Mojo,
even cranky old Jeffers,
if he were alive,
couldn't help but love
your shabby humanness.

Wake up in Bakersfield. Vera, Jim, and Lenny are out of the boxcar and Ed is handing blankets and water jugs out to them. I get up and go over to say good-bye.

"See you fellas again sometime," says Ed, "hope your trip is safe the rest of the way. You ain't got far to go now. Remember to watch out for yourselves in them Colton yards."

We shake hands then watch them cross under a bridge and disappear into Bakersfield.

Hang out in the yard a few hours trying to catch out of Bakersfield. Just before ten a.m. Jim finds an open boxcar on a train headed for Colton. We gather everything up, cross two or three trains and walk down to our empty. We're all pretty excited about getting on with the trip—after we reach Colton, L.A. is only thirty miles more.

Our train snakes out of the Bakersfield yard slow at first, then, as the back end clears the yard, the engineer highballs it and doesn't slow up until we reach Tehachapi Pass. Here, at the base of the mountains, two more helper units are added on. It's well before noon and already very hot.

It only takes a few minutes to add on the extra units and we are on our way again. The pass is steep and very curvy. The train pulls us up so slow that you can get out and walk at some points. We sit in the door with our legs hanging out and as we climb higher it gets more and more beautiful— green rolling hills below us, old grey oak snags and circling vultures. So little of southern California left wild, but up here, looking across these valleys covered with spring flowers, it is hard to believe we are so close to Los Angeles.

Soon we reach the famous Tehachapi loop. A huge figure eight that takes quite awhile to complete. At one point we go beneath a bridge as another part of our train crosses over us then back around, to the beginning, where the caboose seems to be traveling ahead of us. It is quite a sight.

We finally reach the summit where they break up the train and disconnect the helper units. On the way up the pass we had noticed that one of the wheels of our boxcar was smoking. Thinking it was just stress from braking we didn't concern ourselves too much with it but now we were beginning to think maybe we should find a brakeman and let him know. But before we have the chance a brakeman comes over from the caboose to see about it.

"Howdy," says Steve to the brakeman, "we were just going to go and find one of you guys to tell you about this smoky wheel." The guy climbs under the car, "Yeah, we saw it coming up the pass. There's not too much we don't notice. Any of you been messin' with this hand brake?"

We can tell he's a little uptight—maybe thinks we've been messing with the car.

"Nope, none of us," says Steve, "when I ride, I ride with respect for the trains."

Steve jumps out of the car where he can talk with the brakeman as he's working on the wheel.

"In fact," Steve says, "I've been thinking alot on this trip about how the hobos could be a benefit to the railroads. Like this smoky wheel for example. What if none of you would have seen it?"

The brakeman keeps working on the wheel and now Steve's down on his knees where he can talk easier.

"One time in Wilmar, Minnesota, there was this tanker car full of ammonia. We could smell something strange so we walked down the train to take a closer look. This was in the middle of the night and as we got closer to the tanker we could see the ammonia floating just like mist through the yard lights. You couldn't breathe if you got too close. I went right to the tower and told them about it. You know, they really appreciated me letting them know."

The brakey starts to loosen up some. Steve gets down on the ground next to him and asks if he needs any help.

"Naw," says the brakey, "if you got hurt my butt would really be in a sling. Thanks anyway. You guys going on into Colton?"

He tells us we'll be in Tehachapi an hour and that we should be pulling into Colton around four or five.

MINOT
 for Pat

Walking down the train in Minot, North Dakota,
tired and wind burned from riding too long outside,
cursing Burlington Northern
 with each closed boxcar I pass,
I throw my gear on the gravel ballast
and sit in the shade of the train—
 heat sick
and lonely for you.

Last night I slept under shooting stars
 on a windy flatcar
and dreamed myself home—
 dreamed I held your face in my hands
by a moonlit sea
and spoke so clearly of love
something wonderful bloomed
out of all this sadness...

I don't know
why we live
as we do
or why these ghosts call my name
from dusty boxcars
that roll lost across America.

I don't know why it is
when I come home
and feel you warm against cold sheets
that none of it seems to matter anymore—
it just doesn't seem to matter.

THE MIDNIGHT GHOST

In memory of Jack Kerouac
and for Michael O'Connor

All day we waited for
that run along the sea,
L. A. to San Francisco
on the hot shot freight
called the Midnight Ghost.

The hobos named her this
for her elusive nature—

leaves with the setting sun
planting roses across the dark Pacific

then flies all night
through blowing fog

 —that ribbon of steel—

that feathery shore
of moonlight
on the breaking surf.

This was your old run
my friend;
the Midnight Ghost,
the Beat line,

 "...the spectacularest railroad you'd ever
 in your wildest little dreams wanta ride,
 like a kid's dream..."

Jack,
sitting in a boxcar
that night in San Luis Obispo,
drinking with friends,
I saw through foggy yard lights
a cut of cars roll slowly past—
the moan and squawk of wheels—
like exotic beasts
headed for extinction.

And I thought then
how your gentle stories
helped find the back doors to America
and how sad to see
new critics
rob with ease the grave
and blame the dead.

But Jack,
the Midnight Ghost
still runs that stretch
you loved to ride
when boots rolled in a coat
made a pillow
and your blood's only blanket
was a poorboy of wine.

After leaving the town of Tehachapi we drop down the other side of the mountains on to the Mojave Desert. For the first time on the ride we get cloud cover and thank God, we get it over the desert. Even with the overcast the desert seems unbearably hot. A certain kind of hot we never get in the Northwest. There is a despair that enters me whenever I go through desert land. A mystical despair I never quite understand. Like a painting by Dali, elusive and beautiful yet I could never hang one on my wall and live with it.

As we pass by Lancaster I check my map. About seventy-five miles to Colton. We should be there in less than two hours. Steve and Jim are sitting by the door, watching the desert, talking some. I move to the end of the car and lie down. I wonder what Ed's doing right now? And Vera and Lenny? I wonder if we'll ever run into Ole again? These were the things I was thinking just before falling asleep.

When I wake up we are already slowing down, coming into Colton. We pack everything up and get ready to jump out before we actually enter the yard. Thirty days in jail is what we've heard you get if you're caught riding in Colton. But the train only slows to a point and then keeps moving steady. Too fast to jump. When it does slow to an acceptable speed we throw our gear out and jump. Instead of staying in the yard we decide to get off railroad property and figure things out from safe territory. We move everything across four trains and climb a fence out of the yard.

Sit under eucalyptus trees on a small strip of land sandwiched in on one side by the yards, on the other side by a giant eight lane highway. We're hungry, tired and dirty and it doesn't take long for us to come to a unanimous decision. "Screw it. Let's walk across that bridge into town, get something to eat

and find out if there's a city bus into L.A. I'll bet it's only a dollar, or less, if we can catch a bus."

We get our gear packed and on our backs. As we start walking we hear someone call out to us.

"Hey, you guys trying to get to L.A.?"

On the other side of the fence stands a Mexican man.

"Yeah," I yell back, "but these yards are too hot to be messin' around with. We're going into town, see how much a city bus costs."

"It's a buck," says the tramp, "I'd do the same if I had any money...or shoes."

He points to his feet and shrugs. All he has is some cardboard tied around his feet. "Got drunk a few days ago and lost 'em. My wallet too."

We walk over to the fence and drop our stuff. He sticks his hand over the fence to shake hands.

"My name's Roberto. Where you guys from?"

After talking with him awhile we check our collective funds and decide there is enough money between us to get Roberto some grub and a ticket into L.A. along with us.

"Someday I'll be able to do the same for you," he says, "you just wait, sometime I'll pay you back." He tells us this over and over. He is really very grateful.

As we walk along the highway Roberto tells us all about L.A.'s skid row. It is his home and he knows it well. Steve pokes along behind us checking through the brush next to the road. Just before we reach the bridge that crosses the freeway Steve yells that he's found something. Stashed in the brush are six brand new bottles of wine. Roberto is beside himself with joy. He tells us someone must have broken into a boxcar full of wine and they hid some of it here. We each stick a bottle in our packs. Roberto finds a brown paper sack and takes two.

When we reach town, we stop at a taco stand and eat. Steve finds a second hand store and buys Roberto a pair of rubber thongs for fifty cents. Then we catch a bus and head for L.A. I knew we were all dirty and probably didn't smell too good but I didn't realize how bad until we got on the bus and everyone around us started checking the bottoms of their shoes. Roberto just grins and holds his nose.

The bus drops us off right in the heart of skid row. Roberto is delighted.

"Come on with me. I'll take you to a quiet bar where you can call your brothers."

So, we follow him through the street past old grimy bars and drunks sleeping on the sidewalks. It seems every dive we pass someone yells out his name.

"Hey, Roberto, where the hell ya been?"

This happens over and over. Every time he's called he tells us to wait just a minute while he goes inside to say hello to his friends.

When we reach the right bar Jim buys us all beers while Steve and I make contact with our brothers. Roberto waits around just long enough to have another beer and make sure we connect up with our families.

"Thanks again for everything," says Roberto, "you just wait, someday we'll meet again and I'll be able to help you out."

We shake hands and then he hits the streets where he is happiest and seems to belong.

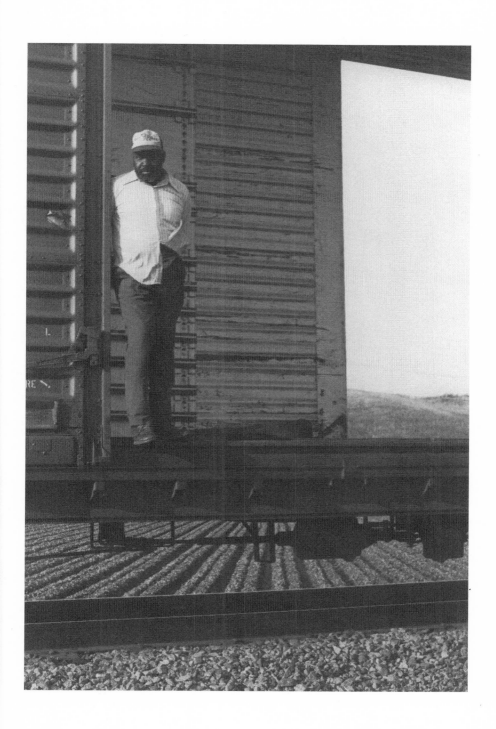

HOBO JUNGLE JINGLE
 for Hal Gaskell

There's a jungle by the tracks
a hobo jungle by the tracks
sleep all night with

clicka tee clack
clicka tee clack

Three old bos' usin' cardboard
as a mat
dream all night to

clicka tee clack
clicka tee clack

And when I die
I hope I go fast
ridin' sweet eternity

clicka tee clack.

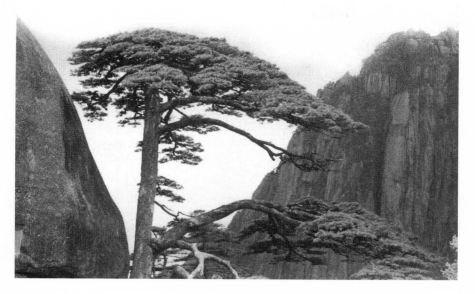

NINE FLOWER
MOUNTAIN

In the summer of 1991, I received a phone call from my friend Bill Porter, who at the time was living in a small fishing village on the back side of Hong Kong Island. He was in high spirits because he'd sweet-talked the all-news radio station he worked for into paying him handsomely to travel in mainland China. His job would be to write several three-minute scripts a day for the radio, keeping track of his travels and brief histories of the places he chose to visit. "I've got my itinerary already figured out for the first trip," he told me, "I'm going to cover the area south of the Yangtze River." This was where huge cultural, political, and spiritual changes took place during the Sung and Tang dynasties that left the country and its people forever altered. Where the great poets of the time were often banished. Where the science and art of tea began. Where ceramics, porcelain, silk, papermaking, and printing soared to new heights. "If you can scrape the money together to get here, I can cover most of our expenses on the fat per diem they're allowing me. How about it? You want to come along?"

Two weeks later we were tramping through the southern sacred mountains of China.

This short suite of poems come from that trip.

NINE FLOWER MOUNTAIN

Perched on the edge of
A cloud-torn ridge
High in the mountains
Of Chiuhuashan
A shaved-head nun
Sweeps alone the entrance
To her vine covered cave

A few tufts of
Wind-blown bamboo
The persistent pine
Growing straight out of stone

A place so graceful
So tough and real
Even the Immortals
Feel a shiver up the spine

She spots us ascending
The narrow path
Sets aside the broom
Pours water for tea

Afterward
We burn a stick of incense
Leave a twenty
On the smokey
Lamp lit altar

Then follow her
Up a rain-polished trail

To Moon Viewing Peak
Where the whole of China
Is spread at our feet

I watch her point out waterfalls
That drape like silk
From old granite cliffs
And wonder what brought her here
So many years ago

A poorly arranged marriage
Some magnificent
Loss of face
Or the simple pleasures
Of living alone
In the profound silence
Of mountains

In the afternoon
Black clouds swirl
Slowly up the valley floor
A signal
We must make our way back
To buses
And dust
And a billion scattered souls

But before we go
Our nun gives us
Mooncake
Gingered plums

And a walk through
The garden

Where we leave her
Grinning
At tiger tracks in the sand.

THREE FOR THE PEARL RIVER

Beneath the hanging banyans
We open three warm beers
And toast the floating moon
That lights the muddy Pearl.

 *

Arm in arm the giggling girls
Stroll down the promenade
Two fragile nests of pink chiffon
Make home their raven hair.

 *

Ten thousand chiming bicycles
Roll down these Kuangchou streets
As lipstick mirrors a lover
Neon graces the Pearl's cheeks.

THE TOMBS OF MAWANGTUI

Inside the crystal coffin
Under dim museum light

The mummified concubine
Looks unhappy with death—

Delicate black slippers
Embroidered with gold

Fine silk robes
Thin as cicada wings

Light
As mist—

And woven in her
Ancient hair

A swirl
Of milky jade

Left as a seal by her lover
To the untampered world.

Western Han mistress
Once as beautiful

As
Yang Kuei-fei

Stares patiently
At eternity

While uniformed
School girls file past.

Western Han mistress
Once as rich

As
The Yellow River plains

Knows the cold wind
Of antiquity

The face of civilization
Where the soul has no witness.

Tonight in my room
I'll light incense for her

Pour a cup
Of rice whiskey

And watch the old
River Hsiang

Shine a skunk-stripe
Of moonlight

Down the middle
Of its starlit back.

TRAVEL ADVICE
Homage to Red Pine

In China
a bus nearly empty
tells you a lot of where
you are headed,
a puddle of puke
on the floor,
even more about
who drives you there.

KUANGHSIAO TEMPLE

In the freshly raked courtyard
of Kuanghsiao Temple,
near the open well
Bodhidharma is said to have dug,
an elderly monk
watches me rolling a smoke
in the shade of a camphor tree.

Green to the ways of the Orient,
a failure in the ways of the West,
I manage a hello
in clumsy Chinese,
"Ni hao,"
and a wave,
and a tip of the hat.

Like some old friend
slipping out a boxcar door,
he double-times it my way,
his thin clasped hands
bobbing up and down
in front of a smiling
weathered face.

Under shaved gray stubble
the shiny tracks of incense cones
burned as a boy on his head
gleam like new skin
in the oily sunlight.

What now?
Do I give him a bow?
Offer my hand for shaking?

In a confused and goofy dance
I do both at once and
my hand comes back
with the image of Titsang
Bodhisattva of Hell,
in a plastic
laminated shield.

A get-out-of-Hell-free card?

I use up the last
of my Mandarin
"hsieh-hsieh, "
I tell him
"thank you,"
and pocket the saint
with a crown of flames,
feeling flush as a bet
sticking fast
with four aces.

Finding Tu Fu's Grave

In search of Tu Fu's resting place
Along the red clay road
Green fields of farmers
Laugh and wave
To ghosts we soon will know.

In search of Tu Fu's resting place
We ascend to Little Heaven
Six tiny angels climb aboard
This cloud now holds eleven.

In search of Tu Fu's resting place
Deep kilns like geysers smoke
Old Titsang must be telling us
Our destination's close.

In search of Tu Fu's resting place
Where slender hemp does sway
We give our friend three heartfelt bows
For helping find The Way.

HANGCHOU

After a day of temple hopping,
my nose full of incense soot
and ears ringing
with the drone
of chanting monks,
I step outside to shake it off,
to watch the good familiar sun
turn West Lake copper
as it drops behind low hills.

Far out on the water
rowboats skim the tiny waves
that glitter
like dragon-scales
in the ebbing light.

And just beyond the temple gate
an old woman sells
Good Luck cigarettes,
plastic Kuan Yins,
and dusty-blue finches
singing from a bamboo cage.

This charmed and gentle town
could tame a hobo's rangy heart,
clear the hermit's mind
of mountains
that graze on floating mist;

Or turn a traveler's
thoughts to defection:
a house-boat
on the Grand Canal.

But this time tomorrow,
from the back of a Chinese bus,
like a dream
I'll watch it vanish,
in a rooster-tail of dust.

Hard to Believe

Hard to believe only
yesterday
we stood on the cliffs
of Cold Mountain

watching swallows
 sweep and skip
across a drifting
cloudless
sky.

Sat in the mouth
of old Han Shan's cave—
smoked our last sticky ball
of Hong Kong hash—

and watched in silence
 the billowing dust
rise behind farmers
in the valley below.

Tonight though—
from the roof of
the Friendship Hotel—
the wet streets of Ningpo
shine with city lights
and are filled with Russian sailors
so drunk
they couldn't hit the ground
with their hats.

Sure, it's not Cold Mountain.
But from here—
above the fray
and narrow lanes—
you see
where this harbor town ends

and the East China Sea
begins.

CANTON ZEN
for Steve

What is the sound
of one horn honking?

BREAKING THE SILK ROAD FEVER

Above the Ch'ilien Mountains
A blooming midnight moon
Brushes a pearly wash
Across the shimmering Gobi.

I open broken windows
Feel the cool desert breeze
And watch a string of
Snow-white camels
Take a long stinging drink.

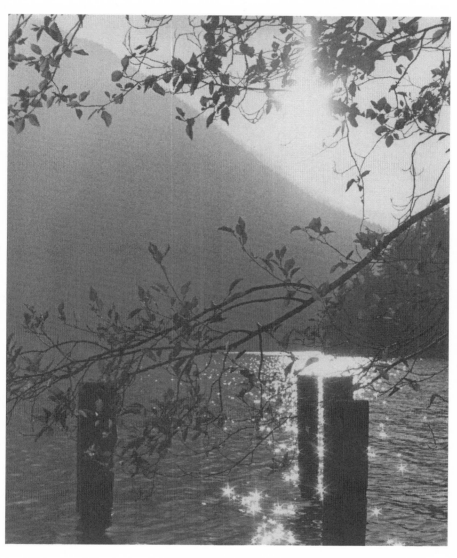

LESSON LEARNED

Whoever is without love does not know God, for God is love.

1 John 4:8

They say love conquers all
you can't start it like a car
you can't stop it with a gun.

—Warren Zevon

POEM: LOVE AND POETRY

Of love and poetry
I know nothing.
The heart?
A bag of tricks.
These poems?
A lucky pull
Of the rabbit
From a hat.

SUMMER GHOST
for Shi

The child is sleeping.
His bed is covered in moonlight.
The small body glows
as if a lamp burned inside.
Moths gather
to dance their wild silence
above his head,
into the dream,
unfolding,
like smoke
through a single string of light.

WHAT TO LOOK FOR IN A WOMAN
for Dane

First,
make sure she wants
to know what kind of man
you are.
She'll see your heart
and stand in long lines
just for a shot.
And remember,
give in to the mystery.
Accept its magnitude.
Love is simple courage
and you'll need it
to prove your bravery.

I wish I had something better
to tell you,
but what I know is this:
the finger-tip touch
to your true love's lips,
the light-as-a-butterfly
brush of her breast,
the culmination of
life and death,
that's where you want to be looking.

The Walk Home

When Sandra Day O'Connor
left the bench of the Supreme Court,
it was love that sent her packing.

Ravaged by Alzheimer's disease,
her once brilliant husband now needed her
more than she needed the court.

When finally the inevitable
crossed paths with the insidious,
he no longer knew her,

his own sons now strangers.

One morning on a visit,
she saw him in the hospital garden
holding another in his arms.

The doctors say
this sometimes happens,
that love's persistence is the last to go.

And she tells this story to America
on the five o'clock news,
her great dignity forged by her love of this man.

There's some joy in his life again
she tells us
and that's all that matters.

With her sons at her side
she turns from the cameras
and begins the long walk home.

FAREWELL

I wore the sweaters
you gave me
wrapped in layers,
one over the other,
wrapped like love
against the bitterest
winter in years.

But this land refuses
to stay cold long,
already there is talk
of resuming work
and repairing rain gear,
the snow long gone
from blankets of rain
the sea blows in.

It's only after
the earth grows warm
that I walk inside,
see your gifts hanging
on the chair,
one over the other,
that my heart leaps and drops
in a single beat
remembering you are gone.

APOLOGY

I still remember that morning in Utah.
It was early.
I woke up to you crying.
It was the first,
and as it turned out,
the last time I ever saw you in tears.
I'm leaving you
you told me
I don't want to
but I must.
I was too young,
only nineteen,
and in matters of the heart
dumb as a sack of hammers
tossed into love's deep end.
So I didn't believe you.
Turned over,
went back to sleep.

A little shy of thirty-five years now,
I hear from old friends
that your two grown daughters
are as beautiful as you.
My two boys are grown, too,
and a grandson for God's sake!

Not much in my life I'm sorry for;
it's true though, there were other women back then.
But only you became a poem.

LESSON LEARNED

Stunning—
the heart's capacity
to endure
the ragged beat
of unclaimed love.
It's only then that
the soul goes feral—
the mind
wild & weedy.
The heart has its limits though,
even the coyote has enough sense
to chew off a leg
to escape the iron trap.

NICE TO MEET YOU
for Pat

You were wearing jeans
and a thin black sweater,
doing dishes in Amigo's kitchen sink.
That old drunk of a wood stove
was tamped way down,
drooling just enough alder smoke
to keep the world fragrant.
You didn't see me come in.
I stood quiet by the stairway,
watching you.
I don't know,
maybe it was all those soapy bubbles
or your wet and slender fingers
working the sponge across a dinner plate;
or maybe just the shift of your hip
as you pushed aside a strand of hair from your forehead,
but there was no doubt,
my mind was meandering.
Then the kids blew in,
bouncing across the kitchen floor,
still excited by their mother's return.
They spotted me grinning down at them,
"Finn's here, Finn's here!"
and that warm, feather-lined chaos
barreled towards me.
You wiped your wet hands,
looked at me
and smiled.
And when you did,
everything evil in this world disappeared.
"So you're Finn," you said.
"It's nice to finally meet you."

Extra Room
for Pat

So it's decided.
Roads are frozen.
Too much to drink.
Forty-five minute drive
back to Mount Walker.
Just stay here tonight.
You can sleep in the extra room.

Never made it there.

But by morning,
you asleep in my arms,
I found extra room
in my heart.

WOMEN

I'm doing dishes.
It's summer.
My wife and my mother
are outside
sitting by the fire
laughing so hard
I have to set the pans aside
and watch.

It's important to
pay attention to joy.
To love that is serious.

Now they are showing
each other earrings,
mom's silver bracelet,
Pat's jade teardrops
looped around her neck.
The night sky
bringing its own
slow jewelry to bear.

It hasn't always been like this.
I wasn't an easy son.

To those who say
redemption
dwells only in the house
of the Lord:
I say
you haven't met these women.

A Desert Road

It's a tough old road
heading out of Vegas.
I look at my father and
see a tear rolling down his face.
He takes a hand off the steering wheel,
wipes it, unembarrassed.
My father's wife is dead.
My mother is dead, too.

Strange,
it took death
to bring my father and me
to this exact point on the planet.
A desert road.
Headed to who-the-fuck-knows?
Who-the-fuck-cares?
My father's wife is dead.
My mother is dead, too.

Tomorrow,
my brother will join us.
His broken heart will
sing the same song.
His broken heart will
throw out the key
as he settles on the seat
next to us
in the same cell.

My father's wife is dead.
Did you hear me?
My father's wife is dead.

CLOSE ENOUGH

I never did find out
how you ended up at Ann's.
But there you were,
coal black hair and
eyes so green
they seemed beyond
any reasonable beauty.
I was sixteen,
a runaway,
trying to stay out of the way
of the law.
You were running too,
from a brutal husband
somewhere in Colorado.

We spent days together,
walking the ridges
of Big Cottonwood Canyon.
And the horse show in Draper...
sitting in the bleachers,
sipping from your smuggled bottle,
watching the ponies canter by.
Watching my green, green heart ripen.

You were my first real woman.
The first to hear me.
The first to begin the untangling
of love's unfathomable knots.

Like everything
in those turbulent times,
one day you were gone.

The only thing left of you,
a tender note saying good-by.

I still don't know if it was love
or the inevitable longing
that trails after it.
It was close enough though,
if I'd had the chance,
I would have dropped to my knees
and begged.

SPARE CHANGE
Homage to Robert Sund

Your little poems I've collected
are beginning to add up.
Four lines a nickle,
six lines a dime,
an honest mistake
turned into mountains,
a shiny fifty cent piece!

Suddenly,
and without warning,
the soul steps forth,
pockets full,
headed for the liquor store.

LOVE POEM WITH JERRY IN IT
for Pat

I finish the poem
and read it to you.
I see in your eyes
a tear beginning.
It's beautiful you say.
Maybe one of your best.
But you love all my poems,
how can I trust someone
who would take a bullet for me?
You roll your eyes:
show it to Jerry then.

But he loves me too.

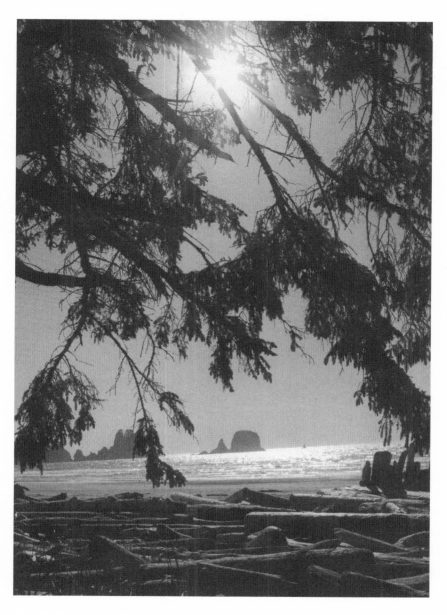

NOT LETTING GO

For Robert Sund

In Memoriam

Unofficial poet laureate of the Pacific Northwest and patriarch of the Ish River poets. A fierce defender of beauty in all its myriad forms—his poetry and art became standards by which many of us measure our own.

Recently a friend said to me, "I've known a handful of people who write good poems, but Robert was the only poet I ever met."

Shortly before his death he was talking with my wife and me about all the haywire things he'd done to scrape by as a poet. After a long pause in the conversation he looked up at us smiling and said, "I've had some ridiculous ideas in my life and only failure has saved me." A hardy amen to that, brother Sund. We will miss you.

> Guiding a stray bee
> out of the house—
> Enough work for one day!

> Robert Sund
> (1929–2001)

Not Letting Go

As much as I'd like to think of it as a connection to the universal, or a link to what we think of as mystery in its fullest form, it was really only my wife Pat's and my turn to sit with Robert while others had a chance to take a break. So there we were, holding his hand, rubbing lightly his pale, pale face, telling him in the kindest way possible it was o.k. to let go. It was clear time had come to an end for our old friend, and we wanted nothing more than to be a soft buffer to whatever came next.

Robert had no interest in giving it up. Not that he was afraid of death, though he hit the brakes hard and cranked the wheel hoping to miss that hooded fucker standing smack in the middle of the road. No, it wasn't death, it was life and dirt and love and friends and railing at the stupidity of world leaders he wasn't easy letting go of.

In the morning, when it had all come to an end, Pat and I went to the cafe where Robert often had breakfast. A quiet sadness hung over the whole of Anacortes, and our waitress burst into tears when she handed us our bill. I'm not a huggy kind of guy but I took her hand and smiled into her eyes. We both knew the world hadn't changed, but ours had.

In line at the ferry that would take us home to Port Townsend, in a strange but warm blanket of grief, Pat told me a story about Robert. When she lived in the miner's cabin down the beach from him on Shi Shi beach, she would visit him for tea in the mornings. She was struck by the beauty of his chosen form of poverty. Not the poverty of want or of cities that tear down the soul. But a poverty of stuff, a letting loose of all that's not needed, and what was needed had been distilled into a simple, profound elegance. A clay teapot. A river polished stone. A cedar plank door that held

off the sea's relentless blow. When she finally moved back to town, she went through the cupboards in her house and threw away every plastic plate, bowl and cup she could find.

A couple months later I was sitting at our local tavern having a beer when a woman I'd never met came up to me and asked if I was Finn. She said she had been friends with Robert and heard I'd been with him when he died. We talked for a few minutes and when she got up to leave she put her hand on my shoulder and said, "What a gift it was for you to have been there with him at the end."

I know full well what she meant and I know she was just being kind, but it somehow hit me wrong. As she walked out the door I thought to myself, "Yeah, it was a gift all right, one I'd gladly return for one more hour at this bar with Robert by my side. A no-money-back return."

Hell, I'd even throw in a set of plastic plates.

TROUBLE & BEAUTY
for Steve

If we are always good does God lose track
of us?
 —Jack Gilbert

We flipped a coin
for bottom bunk
that time in county jail;

watched Orion
hoist his blazing belt
and slosh through a swamp of stars
one moonless
freight train night;

followed Uncle Bill
along those twisting hills of China
where we dined with mountain monks
and were chased by Chinese soldiers.

Trouble & Beauty
aren't easy to figure
though they've trailed
our years of friendship
· like toe-headed little brothers.
"You promised you'd take us fishing,"
they bellow.
"Goddamn it, you promised!"

They say the only sin in art
is passion without purpose.

I mull that one over

dropping nightcrawlers in a can
knowing you'll bring the beer
and I'll spring for ice.

Too Late to Turn Back Now

There was a time
in the old days—
long before silky-sleek cars,
boutique dogs and slippery money arrived—
we had an artist
who lived above the hardware store
on our little main street.

He was fat as a Buddha
and nuttier than a squirrel turd.

Some nights
he would shoot pool
soft as a farm wife collecting eggs,
talk clear and lovingly
of Picasso, Kandinsky,
and Expressionism's
great leap forward.

Other nights
glass would shatter
and the spittle would fly,
yelling down the bar at me,

"It's too late to turn back now,
until you poets realize that,
you'll remain cowards,
not artists."

Years since his death,
that cryptic, unanswered truth
still sends a shiver through me.

He was a bunch of interesting guys
and our small town tolerated
and loved him
as one would a troubled brother.

Back then we understood;
like it or not,
the artist belonged with us.

But as I said,
that was the old days.

HOW TO WRITE A POEM

My dog Walt
steps onto his bed
fourteen and deaf as a stone
paws at it thoughtfully
turns in a circle
once
twice
three times
before setting
his boney ass down
happy as a two-peckered toad.

ART

Story goes that Hemingway
was one of the first to arrive in
Paris after the liberation of France.
His first stop,
a visit to his friend
Pablo Picasso.
Not finding him home,
the concierge of the house
suggested he might want
to leave a gift for
the old Master.
Hemingway thought it
a good idea,
went to his Jeep,
brought back a box
of hand grenades,
and a simple scribbled note,
"To Pablo from Hemingway."
He felt a little sad,
as he drove away,
that his present had no ribbon.

A Fish Tale

As usual I was up and out the door of our beach cabin at the crack of ten a.m. My pal Paul, and my brother and dad, had been on the beach for hours, and more likely than not, their buckets were already half-full of surf-perch. It would take some doing to catch up, so I grabbed my fishing pole, my bucket, beer and bait, and headed for the trail that ribbons through driftwood tall as a house.

After a couple near disastrous slips on wet, sun-bleached snags, I came to where the trail opened onto a mile of empty sand; the sharp crack of breaking surf reduced to soft muffles by a deep, bone-soaking fog. No use looking for friends or family in this soup, though I knew they were out there somewhere—Paul, probably a half-mile down by the jetty and my brother and Dad closer to the cliffs, where the creek drains into the sea. Always good fishing there.

I set my bucket down, and with a few firm twists, screwed it sturdy enough into the sand that I could lean my fishing pole against it. Needed to rig up. Double number four hooks and a three-ounce pyramid sinker to hold off the drift. It was just that simple. But as poet Jim Dodge once said: "Just because it's simple doesn't make it easy."

First cast, my lead flings loose of my fishing line like David's stone at Goliath. "Shit!" Reel in the slack, grateful for near zero visibility to spare myself the chuckles and playful scorn that would have surely come from my fishing buddies. I re-tied a new, $1.28 tripod lead to the naked end of line and made a good cast just beyond the creamy breakers rolling in out of the fog.

Though we were deep into July, it may as well have been February the way it felt on the beach, and the prospect of standing up to my nuts in the cold swirling slurry of an incoming tide didn't sit well with the way I saw the day unfolding. So I let out enough line to get me onto dry sand where I settled in, using an old gray boom log as a back rest; flipped the bail and tightened the line just enough to feel the bump, bump, bump of a hunting perch.

It didn't take long before I decided it was time to find the half-smoked reefer I'd stuck in one of my coat pockets after watching the sunset the night before. Damp, limp and requiring the patience of Job to keep lit, I somehow managed. Now the stage was set, the dogs let loose, and the mind not far behind.

By around noon, I'd kept six large perch, thrown several smaller ones back and watched a knot of sun burn a ragged blue hole above the sea-stacks emerging slow as ghosts. The deep fog was losing. The high summer sun burning it into a thin silver gauze that would vanish in another hour.

It had cleared enough that I could see my brother Craig down the beach, and by the rainbow bend of his pole, he had on a lunker. Well beyond hootin' distance, I set my fishing pole aside, re-lit the stubby reefer, and watched him work his fish onto the beach. Just by the silver glint as he lifted it into the air, I could tell it weighed in at a pound and a half — maybe two. A big fish for this beach.

My brother was always the superior fisherman. Still is and always will be. Even as a kid, he had the gift of a diamond-clear, laser-like attention that's required to become a top-notch angler. I, on the other hand, was happy until the bite slowed down, then it was off to rifle through cattails looking for pollywogs or causing some small trouble, all because of that seductress, boredom.

The only time I can recall claiming anything close to a victory when it came to fishing with my brother, was when we went camping for the first time by ourselves at Little Lake. My dad had decided it was time for my big brother and I to be given the slack to forge on our own a couple nights. I was seven or eight, my brother nine or ten, and my dad's permission was like being handed the keys to Oz.

After the talk about being careful with our campfires — and no you can't take your pellet guns, and how sound carries across the lake at night so don't be making a ruckus that wakes up other campers — we set off on our bicycles with fishing poles, an empty one pound Folger's Brothers coffee can for boiling up crawfish and three packs of hot dogs. Life had opened its gates to endless possibilities and we were poised to pluck them.

The grand moment came on our last day fishing. It was too hot for fish to be feeding and I hadn't gotten even a nibble in over an hour. Bored to the point of utter misery, I dropped my pole in the dirt and begged my brother.

"Let's do something else for awhile. Wanna go catch crawdads?"

With the patience only an older brother can muster after a couple days watching over a little brother, he let the question

hang for some time in the air before twisting his head, slow as an owl would, and telling me in a way so objective it could have come from Sir Isaac Newton:

"Hey, guess what Skid-mark, you wouldn't even be here it if wasn't for me. Mom knows I'll look out for you. We gotta go back to school tomorrow, we gotta be home before dark, we got three, maybe four more hours left, and I'm spending them fishing."

I let all that he said sink in slowly. Kneeled down in the dirt and pulled the wings off a flying ant:

"Yeah, well you know what, I can catch a fish before you do using a booger for bait."

"Sure you can butt-lips."

"Bet ya an orange soda I can," I shot back.

"Deal!"

Craig stood on the shore pitching a gold, Colorado spinner out onto the breezeless, glassy lake, the only ripples showing were those made by the slap of his lure. I'd decided the orange-soda challenge would require me to somehow make my way to the end of the giant eucalyptus blow-down we were camped next to. It was half-sunk and stretched a quarter of the way across the lake. I was apprehensive because the last time I'd tried this was the summer before, and I ended up slipping and swimming back to shore. So I walked its hefty girth till it slimmed to the point I felt spooked enough to straddle it like a mule, laid my fishing pole across my lap,

and scooted my way to its end, not unlike a dog dragging his ass across a carpet.

"You fall in Finn, you're ridin' your bike home wet," my brother reminded me, "Mom didn't pack any extra clothes."

I could see, in the deeper shadows of the floating log, lighter shadows of bluegill schooling up in the shade beneath me.

"Craig, there's fish galore out here!"

"Great. Too bad they're not hittin' on boogers."

I'd almost forgotten the bet entirely with all the excitement of fish. Craig didn't consider what I was doing fishing at all and paid little attention to my enthusiasm.

"I'm not kidding, there's bluegill everywhere. Goddamn!"

"Quit yelling will ya, I'm standing right over here for shit's sake!"

I squeezed three split-shot about a foot above my hook, then went to my nose for bait. Craig was laughing as I held it up for him to view, to prove it was all fair and square. A booger that belonged in the record books of Boone & Crockett. A booger only an eight-year old, with the assistance of a hot, dusty day could produce.

As I dropped in my line, long before the split-shot disappeared into the deeper tea-colored water, even before I had time to click my bail shut, Bang!, I had one on! I nearly dropped my fishing pole in the lake with all the unexpected action. I didn't believe for a second I could catch a fish on a booger, any more than my big brother did. In the stunned

confusion of success, and the fog of unreliable reflexes, I abandoned my fishing reel altogether and grabbed the line at the tip of my pole, bringing my fish in by hand, slow but sure, a nest of tangled fishing line building behind me.

"Goddamn! Goddamn!" I kept repeating.

"Don't let 'em swim under the logs, or in the weeds," my brother instructed.

As his fat, blue head surfaced, I dipped my hand into the water and secured him through the gills with my index finger. I could hear Craig splashing along the snag, knee-high in lake water, scrambling to toss me a stringer.

"Get 'em on the stringer before you unhook him, Finn."

In my long, eight years of fishing, I'd never caught, or even seen, a bluegill this size. Neither had Craig, and he said so.

Later that day, when it was time for us to ride our bikes home, we stopped by the tiny tackle shop where we bought Milk Duds, Cokes and bait. Craig paid up without protest and handed me my orange soda.

When Mel, the owner of the shop, handed Craig his change, my brother said:

"Hey Mel, look what Finn caught out on that eucalyptus snag laying in the lake."

Craig lifted my fish from the bucket, and when he did, Mel's eyes bugged out just like Wiley Coyote's in the cartoons.

"Jesus Christ boys, what the hell you using for bait?"

Craig grinned at me and said:

"You tell him, Finn."

<center>***</center>

I watched my brother fish up and down the beach till late afternoon. I kept count and for every fish I brought in, he caught two. The world is as it should be I laughed to myself, then grabbed my pole and bucket and headed his way to take a look at his catch.

When I arrived he popped a beer and handed it to me. I flopped down in the sand next to him and watched as he reeled in to re-bait. He glanced into my bucket and asked me:

"Have much luck?"

"Well" I said, "no one's gonna starve tonight, but no one's gonna get fat either."

He tipped his bucket so I could see inside. The smallest he had was larger than my biggest fish.

"Jesus, Craig, you've got three in here the size of dinner plates, they must be a couple pounds each."

We sat on the beach a while shooting the shit and drinking another beer. I pulled my rubber boots off, dumped out the sand, then stood up and picked up my gear.

"Guess I'll walk down the beach and find Paul. Go to the cabin and have lunch with Pat and Kate. The bite has slowed enough that I'm getting kind of bored."

My brother looked at me and smiled:

"Now there's a news flash."

WHITE TRASH ZEN

It makes him happy
standing waist deep
in froth-lit surf,
holding his fishing pole
chest high
as he reels in a fat,
pink-finned perch.

Happier still,
on an empty beach
where the only art needed
is how to bait a hook—
abstractions floating off like seaweed
with the outgoing tide.

It makes him grin
like an idiot
watching the low sun
drop lower
till it disappears behind the jetty
as he makes a last evening cast.

He won't pack up his gear
till the heavens release
a few stars,
or his bucket of perch
is full, shining
like a bucket of silver coins.

Heading home,
on a path through polished drift,
the immense joy of a day
learning nothing—

the sound of pounding surf—

the slate wiped clean.

When he reaches the gravel road,
he sees the cabin's
lantern lit,
and the beginnings
of a moon,
in the shaggy
crowns of spruce—

hears the laughing
porch of friends
waiting to reward his
lavish triumph

with a beer in one hand,
and a fillet knife in the other.

LA PUSH

Walking the flats—
through brushed huckleberry
and tall, tough salal—
I find the place
we spread my mother's ashes
nearly a decade ago.

You can hear the rolling ocean
just beyond this sandy hump
that rises in the silvered-light
of drift-logs,
luminous,
in thin coastal fog.

I hope she's happy here.
She was more than just a good woman.
Always that glitter of faith rendered
from a heart
big as these old-growth spruce.

Before I leave,
I make her a headstone

of the perfect blue sky,
 above a perfect blue sea

with all its deliberate beauty.

TRUE LOVE

Standing on the beach fishing,
my wife and grandson
show up with a sandwich
and potato chips. Thought you might
be hungry she says and gives
me a kiss like the ones
when we were young.
It's an astonishment—
thirty-nine years together—
watching her stroll in the sand
picking up sea-shells with my son's
only son,
my old pecker rising,
just a little bit slower.

DANIEL

John was sitting in the driver's seat of the crummy when Ned showed up with the kid. Not really a kid, but a very young man. John figured him at seventeen, nineteen tops. It wasn't the number of years that worried John, hell he'd been planting trees himself at that age, it was the street shoes and city shirt that got him to wondering what the fuck Ned was thinking. John knew how this would turn out, and for that matter, Ned knew it too. The whole crew knew and they wondered the same as John, what the fuck was Ned thinking? So at the end of the day, when the kid couldn't cut it, John told Ned he'd have to drive the boy the fourteen miles of logging roads back to highway 101, where the kid had at least a fighting chance to hitch a ride back to civilization. "What the fuck were you thinking anyway, Ned? The kid didn't even have boots or raingear!" Ned mumbled something in reply, but it wasn't a protest. He grabbed his keys and was making his way to the truck when John stopped him and said never mind, he'd take the boy back himself. John knew Ned had been running the coast towns for two days looking for experienced tree planters to help finish up the contract, and he was beginning to feel remorseful for being so short with Ned. John took the keys from Ned and gathered up the boy. People who didn't know John thought him gruff and even mean. Ned knew better. He'd worked with John for years and was well aware of his big-as-a-watermelon heart, his soft spot for the young and inexperienced. The whole crew knew this about John too, and they all smiled and chuckled as they watched the battered pickup bounce down the dusty logging road. When John got to the highway, he cut the boy a check for a hundred dollars, (more than twice what he should have paid him) told him when he got to Coos Bay he could cash it at Del's Cafe (the boy had no ID), and that Del would most likely put him to work washing dishes if he wanted to build up a grub-stake. When

John let the boy out of the truck, he pulled a purple Crown Royal sack from under the driver's seat that was filled with quarters and dimes he used for the Laundromat. "There's a Greyhound bus comes by here twice a day. This should be plenty to pay your ride to Coos Bay. Just flag 'em down. The driver will pick you up." The boy looked to John as though he might begin to cry, so John quickly extended his hand to the boy, hoping to make him feel something close to an equal, "Hey, you know what, I never did catch your name, what is it anyway?" The boy wiped his eyes with the long sleeved city shirt and said, "Daniel."

Outdoor Work

The one time
I experienced what my Buddhist friends
call enlightenment,
that recognition, sharp and clear
as a shot of cheap whiskey,
was packing my tree bag
on a landing pooled in drained skidder oil
in a clear-cut
big as the town I lived in,
understanding
finally and fully,
the rotting extravagance of greed.

MARRIED

John didn't know what to make of it. He'd just returned home from Forks after winning enough tree planting bids with the Forest Service to keep two crews working for five months. When he walked through the door his wife gave him a kiss, a beer and sat him down at their small kitchen table. "Honey," John's wife said, "I got a call on the CB from Ned about an hour ago. Sounds like something's gone seriously wrong at the Castle Rock show. He said if you don't want to use the company insurance you better bring some cash. That's all I could make out, that damn radio is getting so old and garbled I couldn't make heads or tails of the rest." John finished the dinner his wife made him—a nice chunk of Steelhead that she herself had caught just a few days earlier out of the Chehalis river, and a slew of potatoes fried in duck fat with rosemary and garlic. John knew it was going to be a long night driving that god-awful freeway all the way to Castle Rock, then off the blacktop to the gravel side roads that would lead him to the logging road that would take him to the problem he still wasn't sure of. John's wife loved him very much, and had for many years. She packed him a slice of rhubarb/apple pie for the trip and hugged him in the way that said, "When you get home and slide into bed, I'm going to slip out of this nightgown and love you till the sun shines so bright it will blind us both." John never loved anything like he loved his wife, and she knew it in a gentle and tender way. It is what kept John in the woods. It is what kept John's wife by his side.

On My Tenth Anniversary
as a Treeplanter

Nearly a million trees older now
I remember when my children
Were shorter than me
And the hair on my head was
Thick as a stand of doghair hemlock.
No regrets though,
The friends that I love
Still work by my side.
But sometimes,
On cold rainy nights,
These stubborn knuckles
Click and hesitate
When I set down the wine.

MAKING IT RIGHT

When John got there he could see Ned in his headlights standing with the log-truck driver who was holding a .45 Smith & Wesson in his hand, thankfully it hung at his side in a loose and relaxed sort of way. The log-truck driver's wife had a sixteen-gauge shotgun but things had cooled down enough that she'd unloaded it and laid the gun on the hood of their rusting Ford Falcon. Thank God for Ned, is what John was thinking. Ned had the way about him for smoothing things over and calming folks down in times of great distress. Over the many years they'd worked together, John had seen Ned disarm some ugly situations, and this one was a doozie. When John stepped out of the pickup, the first thing he saw in the headlights was the company crummy nosed into the log-truck driver's double-wide. Ned sidled over to John and explained, as he understood it, that Pete had gotten a snoot-full down in town to reward himself for finishing off (all by himself) the steepest, nastiest, slash-strewn rock pile of a unit that all the crew agreed was the worst they'd ever seen. Coming back on the mainline, Pete turned off onto what he thought was the spur road to camp and ran smack into the double-wide. When he slammed on the brakes all the hoedads in the back flew forward and whacked him in the back of the head. Dazed, Pete climbed out of the crummy, head bleeding like only a head wound can, to find the log-truck driver's wife in a bathrobe holding a shotgun to his face. Not but a minute or two later, the log-truck driver arrived home after dropping off a last late load to find his wife holding some crazy, bleeding, longhaired hippy hostage with her shotgun. He grabbed his pistol, stepped down from the cab of his log truck and ordered Pete to go sit down on the splitting round next to the wood pile while he checked out the damage to the double-wide and tried to sort things out. "And that," Ned told John, "is the long and the short of it." John shined

his flashlight over to Pete still sitting on the splitting stump. Pete was holding a Kotex to the back of his head that the log-truck driver's wife had found to stop the bleeding. "Pete, you O.K.?" "Yeah, just ducky John, thanks for asking." John knew that he had to make things right, so he pulled a bottle of unopened Jack from the toolbox, grabbed the company checkbook off the dash and went inside with the log-truck driver and his wife. Ned never did ask John how much it cost him, figured it wasn't really his business, but when they came out again the log-truck driver was smiling and shaking John's hand. He shook Ned's hand too and even slapped Pete on the back and said something funny to him. John never did ask Ned how he got to the scene so quick or how he put out the fuse that could have made that night a very unhappy one. John and Ned rarely pushed one another with questions, and more often than not, answers seemed to miss the point anyway. In the end, it was all just part of making it right.

OUTDOOR WORK II

One of the benefits of tree planting
was finding gear the loggers or
fire crews left behind. One time
a chain saw that fired up with a little
fresh gas, miles of fire hose with beautiful
brass fittings you could sell back
to the Forest Service. Another time
a complete set of climbing gear—
harness, rope, spurs—the whole
shitteree. Traded it to a young logger
for a pair of thinning chaps and
a brand new Pulaski. Not long after,
he nicked his rope limbing up a spar tree,
dropped sixty feet and broke his back.
That was many years ago. I still
own the Pulaski.

END OF CONTRACT
for Paul Townsend

Three weeks working the woods
and we're finally heading home.
When the crummy breaks down,
end up in the freight yards
you and me,
waiting on that south-bound S.P.
Another step up
in a long,
lustrous career.

Silver Lining

Sure we had to flap our arms
and pace all night
that frozen boxcar floor,
and it's true
our teeth chattered
like an old flat wheeler;
but on arrival,
in the moon-lit rail yards,
an abandoned shopping cart,
with three good wheels,
pushed our burdensome packs
the whole way home.

Freight Haiku

Bad Track

This rocking boxcar bounces me
out of sleep—
even my pack
walks the floor.

After the Blow

From this rattling flatcar
we watch Saint Helens steam—
my friends
covered with dust.

Tacoma Bust

Railroad dick throws us off—
we hop back on—
the smiling fisherman
waves.

Catching Out

Jungle up in Scotch Broom
under honking V's of geese
 —southbound—
all of us.

Headed Home

The tramps think we're nuts
mid October and
riding against the geese.

POEM FOR FATHER DALEY

Sitting in the park eating lunch,
listening to a heated argument
between a true believer
and a hardened atheist.

In my mind,
I see old Han Shan on his mountain
doubled over in laughter—
two slaves shackled
to the same demands of faith.

MORE DIFFICULTY ALONG THE WAY
for Tim McNulty

> "Before enlightenment chop wood, carry
> water. After enlightenment chop wood,
> carry water."
>
> —Zen Proverb

Too old to carry water
Hands that shake when
I fire up the saw
All I want is to sit
And remember
When pissing wasn't hard.

TWO FOR TOM JAY

Philosophy 101

Xeno was absolutely right
up till that arrow
slipped between two ribs
and entered the heart.

Scratched Haiku Found on Condom Machine

This is the
crappiest gum
I ever did chew.

POEM FOR MY GRANDSON
TRAVELING IN AUSTRALIA

On your twenty-first birthday
in a land far away
tonight I'll drink for the two of us.

CRAZY QUILT HAIKU
For Pat

So that's what happened
to my favorite old
Hickory shirt!

EMAIL HEAVEN

Just because it's been deleted
doesn't make it gone.

SPRING

Snipping a few inches
off my beard,
I usher winter
out my door.

NOTES

Photographs by Steve R. Johnson:

William O'Riley on the Midnight Ghost, 1981.

Rooftops, Interbay, Seattle, 1965

Honest Joe. Hamburger Flats, Bellingham, Washington, 1966

Monty The Wobbly, Wishram, WA 1984

Laddie and Dennis at the Wishram Bridge, WA, 1984

North Beach, San Francisco, 1967

Approaching bridge at Wishram, Columbia River Gorge, Washington, 1981

Pinnacles, Columbia River Gorge,WA 1985

Fresno Boxcar, Fresno, CA 1981

"On the Fly," Chehalis, WA, 1965

Marvin and Max, Hamburger Flats, Bellingham, Washington, 1966

Between the trains, 1981

William O'Riley and lettuce fields, south of Frisco, 1981.

Friendship Tree, Huashan, China, 1991

Lake Crescent, Olympic National Park, WA, 1977

Shi Shi Beach with Jeremiah, WA, 2007

Nine Flower Mountain:
Chiuhuashan—one of the Four Sacred Mountains of Chinese Buddhism. It is located about 20 miles south of the Yangtze River in Anhui Province. Because of its nine outstanding peaks, the great Tang poet, Li Po, gave it the name Nine Flower Mountain.

Kuangchou—also known as Canton, was the first Chinese port opened to foreign trade.

Yang Kuei-fei—the most beautiful concubine of Hsuan Tsung , who caused the erotically infatuated Emperor almost to ruin his kingdom by licentious extravagance. He ultimately was forced to have her strangled in order to pacify his revolted people.

Kuanghsiao Temple—the earliest and most famous Buddhist temple in Kuangchou. In 397 A.D., the Indian monk Dharmayasa went to Kuangchou to preach Buddhism and built the main hall of the temple, in which a succession of Indian monks preached and promoted Buddhism. In 676 A.D., Hui-neng had his head shaved beneath the bodhi tree in the temple complex. He later founded the Southern branch of Buddhism and became known as the Sixth Patriarch of the Chan (Zen) Sect.

Bodhidharma—the first Buddhist Patriarch of China. He arrived in China from India about 500 A.D. and died in 528. His birthday is celebrated on the 5th of the 10th moon. He is regarded as the founder of the Chan or Meditative School of Buddhism.

Titsang—a Buddhist bodhisattva who opens the gates of Hell and rescues suffering souls. Some write of Titsang in ecstatic, almost New Testament terms, as one who has sworn to take upon himself the sins and burdens of all creatures and devote himself, at the cost of any anguish and toil, to the salvation of mankind. Titsang is affectionately referred to as *The Lord of Hell.*

Tu Fu—generally regarded as China's greatest poet, lived during the Tang dynasty (618 A.D.) He was born to a family of

wealth but sank to the lowest rung of the economic ladder. He shared the lot of the common folk and therefore had a deep insight into the calamities and suffering in which they were involved. He made his poetry a vehicle for the people, as well as a faithful account of his own tragedy.

Finn Wilcox worked in the woods of the Olympic and Cascade Mountains with the forest workers co-op, Olympic Reforestation, for twenty-five years. From the mid-seventies through the early nineties he was an editor for Empty Bowl Press. Along with Jerry Gorsline, he co-edited WORKING THE WOODS, WORKING THE SEA: an anthology of Northwest writings. He and his wife, Pat Fitzgerald, live in Port Townsend, Washington